To: _____

From: _____

To all the girls who grace these pages
(and to their girls as well)

Published by
Shake It! Books, LLC
P.O. Box 6565
Thousand Oaks, CA 91359
Toll-Free: (877) Shake It
www.*shake*that*brain*.com

Photograph, page 39: Black Box Collection
Photograph, page 95: History of Women's Basketball Collection

This book is available at special discounts for bulk purchase for sales promotions, premiums, fund-raising and educational use. Special books or book excerpts, can also be created to fit specific needs. Got a need? We'll try to fill it.

ISBN: 1-931657-01-7
10 9 8 7 6 5 4 3 2 1

First Edition

Contents

Finding Her Joy

I enjoy being a girl!
—*Richard Rodgers and Oscar Hammerstein*

Here she is, your own little girl.

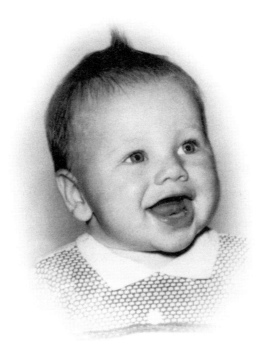

"You bet I'm happy—I'm having a good hair day!"

Made of sugar and spice and everything nice…

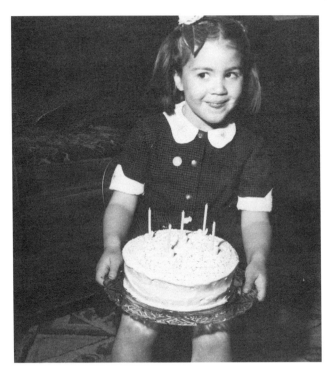

"Anyone for Angel Food?"

It's the spice you have to watch out for.

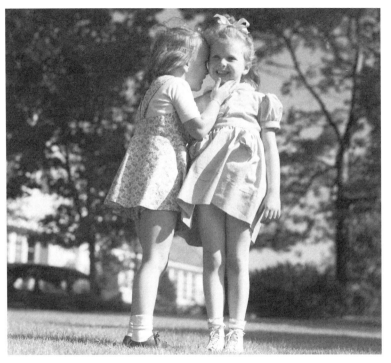

"We've got a secret, we've got a secret!"

Mostly, she's just busy being a girl,
exploring the world and finding her joy
—like a love for books and the stories they tell...

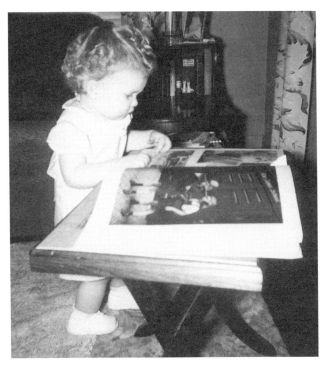

"I sure hope it's a happy ending."

And a love for shoes with their magic spell.

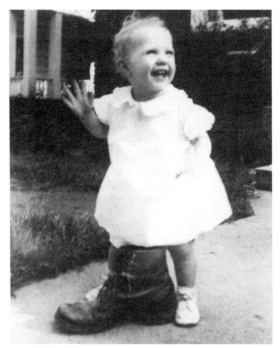

"This boot is made for walking
and that's just what I'll do!"

She'll also discover some fine new friends.
From a litter of puppies for whom she can care...

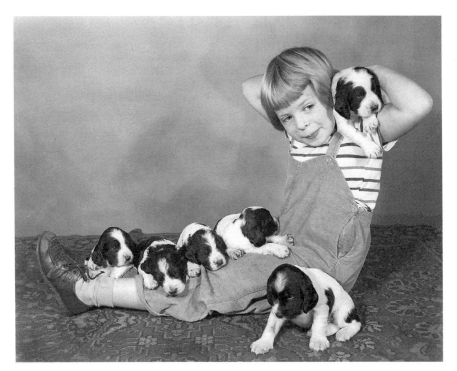

"Gee, I think they like me!"

To a best friend ever, whose world she can share.

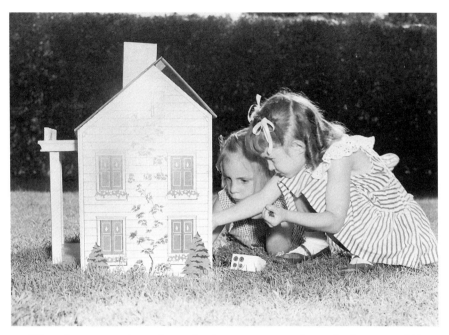

"See how moving that chair opens up the whole room?"

Tip 1

Let her have fun.

Life will get serious soon enough.

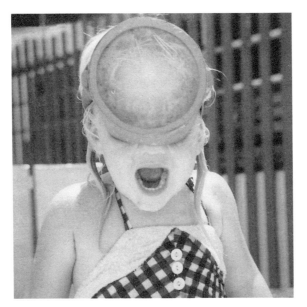

"Hey, who turned the lights off?"

Let her explore, create a world of her own.

"Welcome to our house!"

Find a talent for skating, a passion for ballet…

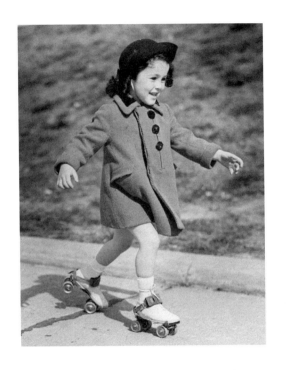 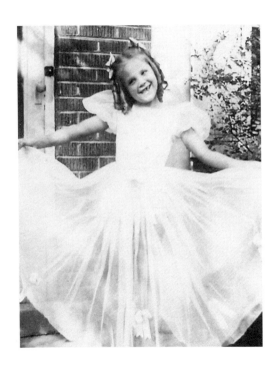

Or maybe a way to combine the two.

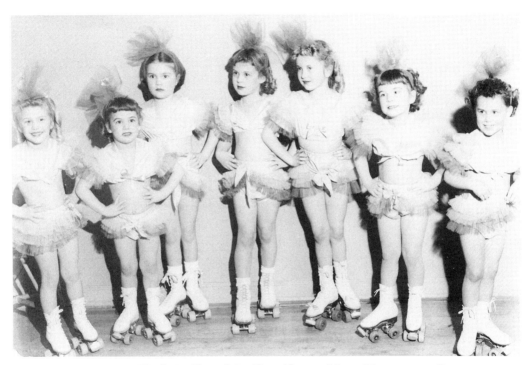

"It's called *Ballet d'Roller Skate*. Very European."

And when it comes time to mix up a cake...

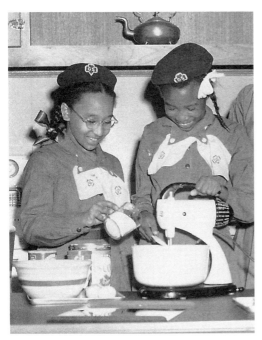

"Look out, Martha Stewart!"

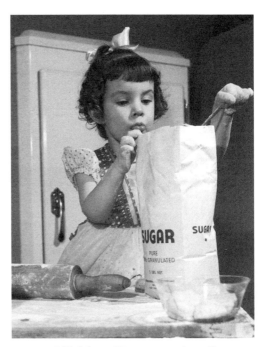

"Shhh... I'm counting."

Or prepare for tea...

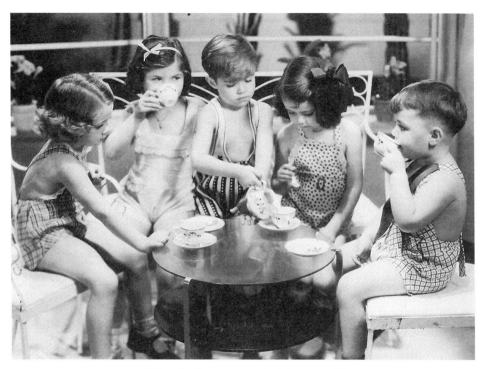

"Don't forget—pinkies out!"

Try not to say, "Now's not a good time."

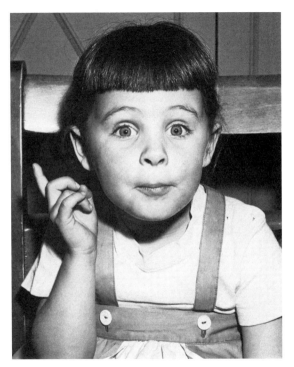

"Sure you don't want to reconsider?"

Tip 2

Find the time.

She'll be grown before you know it.
Enjoy her while you can.

"Calm down! I'm just pretending."

Help her to swim…

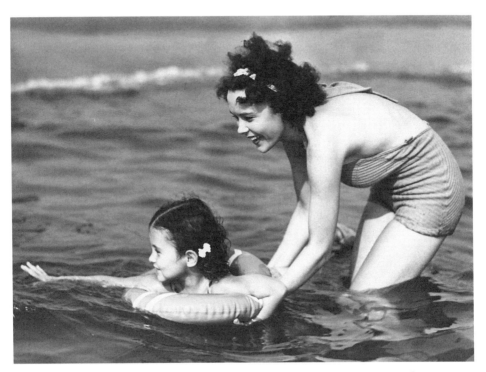

"Hey, I think we're ready for the English Channel!"

Teach her to ride…

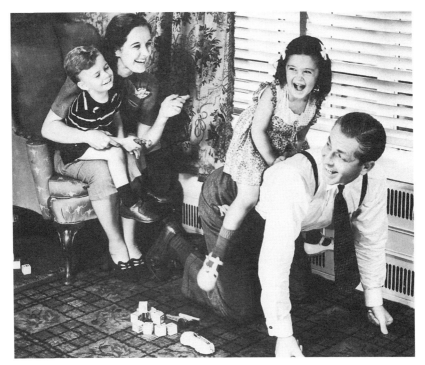

"Hi ho, Daddy-o!"

And be there for her show, beaming with pride.

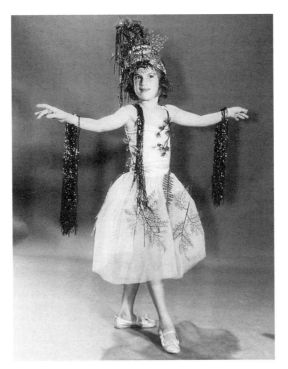

"Look at me, I'm a seaweed!"

"Isn't life grand?"

Searching For Beauty

Beauty is only skin deep.
—The Temptations

Who will she be?
What does life hold in store?

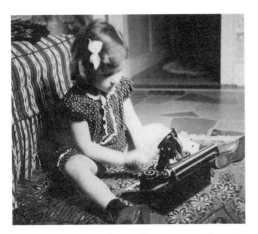

"I'm going to be a famous writer."

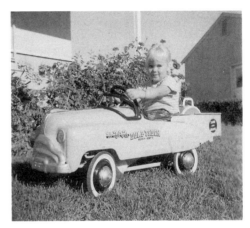

"I'm going to run
my own trucking company!"

No matter what happens,
one thing's for sure:

"I'll marry a prince and live happily ever after?"

There will be days she feels pretty and free…

"How am I? I'm adorable."

And days when she frets
about appearance and dress.

"Fabric softener would have been nice."

Tip 3

Teach her about beauty.

Teach her that being a "beautiful girl" is not just about looks. It's about her thoughtfulness, energy and achievements as well.

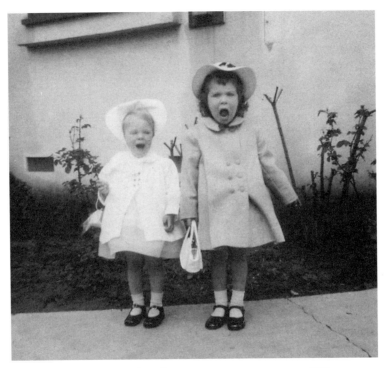

"What, looks don't matter anymore!?"

Of course they do.
It's just a question of keeping things in perspective.
So when she wonders…

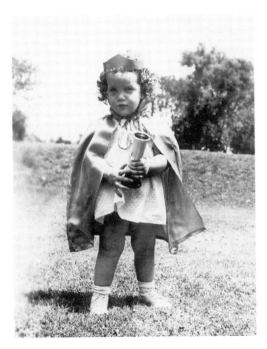

"Are my hips too big?"

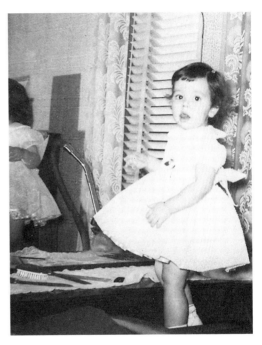

"Do I look pretty enough?"

Be sure to remind her, *and yourself*:
Whether you're still growing up
—or all grown up—
it's not about living up to some ideal...

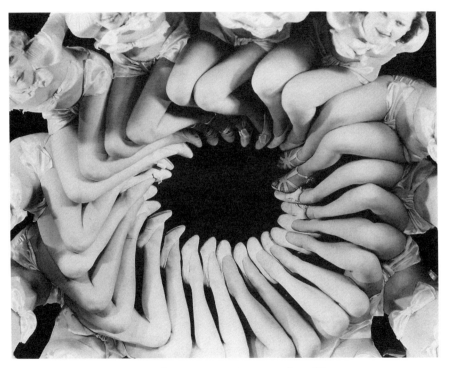

"Look at us, we're perfect!"

Or about being the fairest of them all.

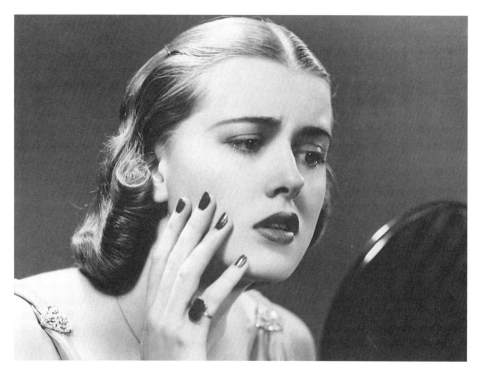

"Uh-oh. Am I less than perfect?"

It's about loving the beauty you do possess,
and working hard to bring out your best.

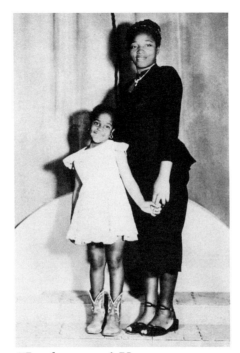

"Look at you! You are strong,
intelligent, and beautiful, too."

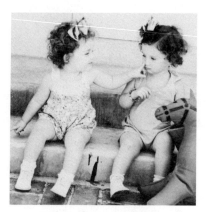

"Your nose is fine.
You *don't* need it fixed!"

Trying Out New Things

Girls just wanna have fun!
—Cyndi Lauper

You're raising her well,
she looks up to you still, thinking...

These are my parents and they know best.
(At least that's what you'd like her to think.)

Truth is, she's starting to look beyond the garden gate.

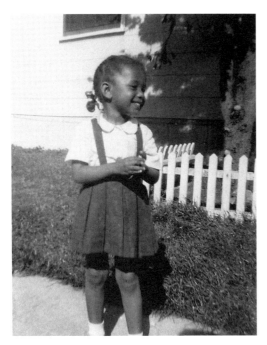

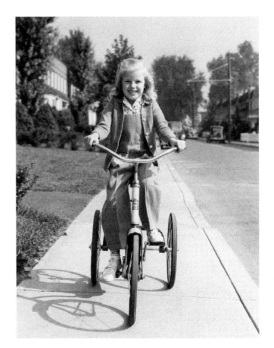

"Ready or not…" "…Here I go!"

She's out the door, down the street,
following her heart to where it will lead.
From playing free on summer lawns…

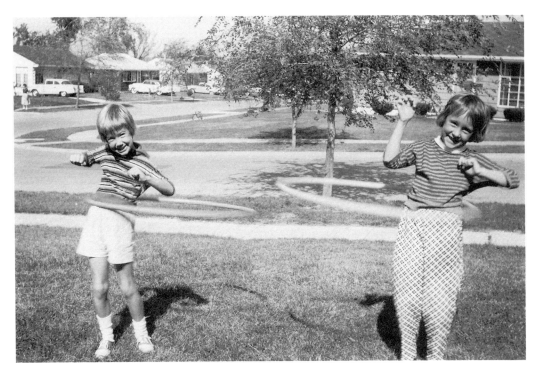

"Bet you can't do this all day!"

To raising high her voice in song.

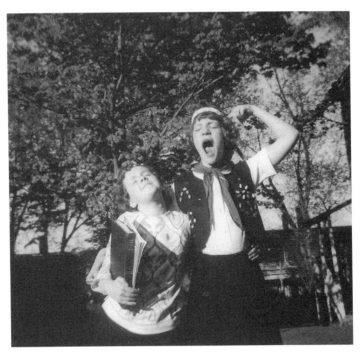

"I am woman, hear me roar!"

From camping out back in a neighbor's yard…

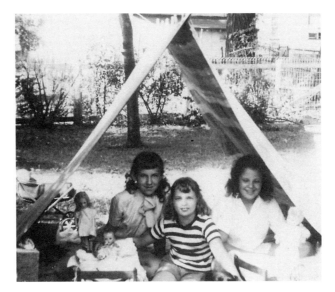

"Ahh, wilderness!"

To discovering that thing called boys.
Boys who'll be sweet…

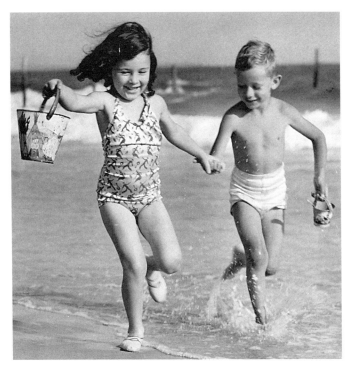

"C'mon, let's get away from it all!"

Boys who'll be wild…

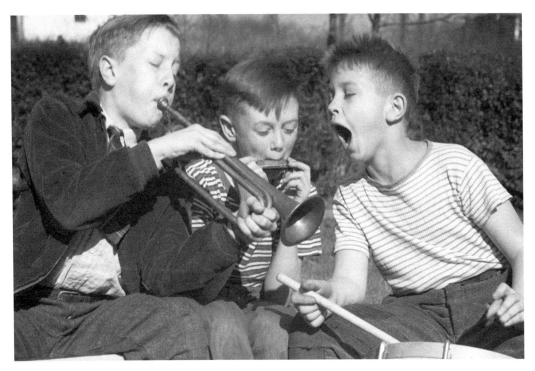

"Born to be wi-i-i-i-ld!"

And boys who'll treat her with lots of style.

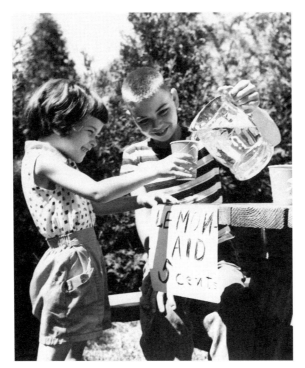

"Don't forget. Refills are free."

Leading to questions of etiquette…

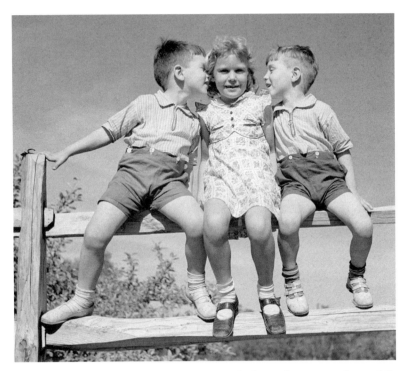

"Can I go out with one now and the other one later?"

Questions of strategy…

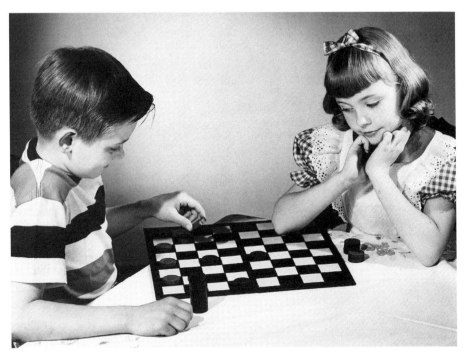

"Hmm… Let him win or teach him a lesson he'll never forget?"

And perhaps the greatest dating question of all:

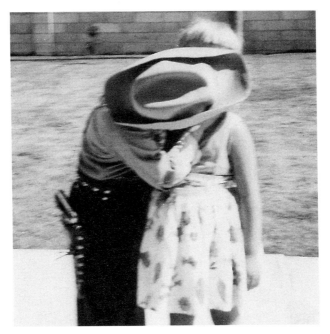

"Will he still love me tomorrow?"

Life moves on, grows more complex.

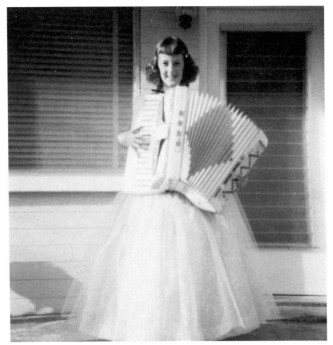

"I used to think I'd go to college on an accordian
scholarship. But now I'm not so sure anymore."

She may even lose her footing for a while.

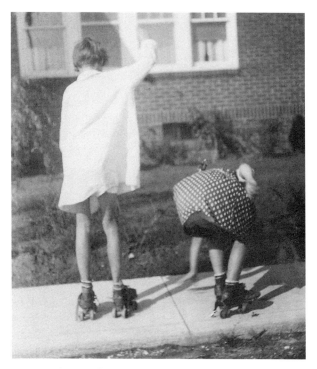

"Is the sidewalk moving or is it us?"

Tip 4

Let her know, "You can do it!"

Encourage her to give new things a try — including sports. Because confidence in sports leads to confidence in life.

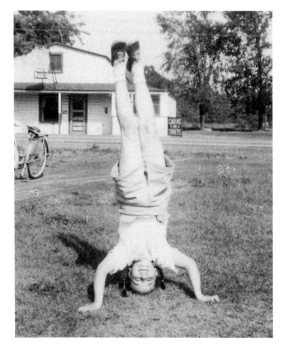

"Talk about getting a new perspective!"

Help her to dream, give things a try.

"You sure I can do this?"

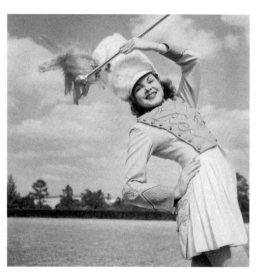

"Girl, you can do it!"

From leading the band, to leading the charge,
help her to spread the word loud and clear...

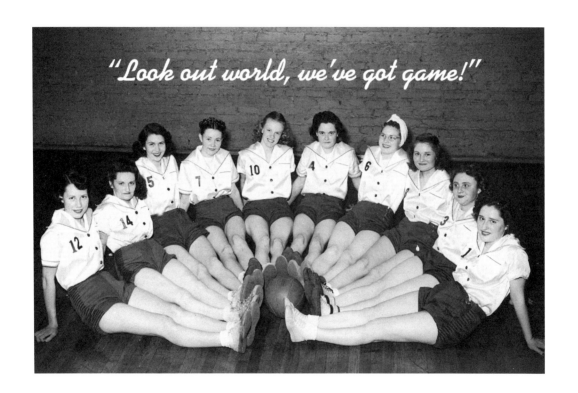

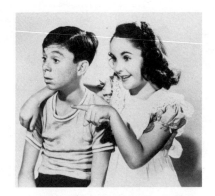

"See? That's how you
make a three-pointer!"

Trying To Find
Her Place In The World

Girl, you're a woman now.
—Christopher Quinn and Bette Ross

Questions keep coming, cutting right to the quick:

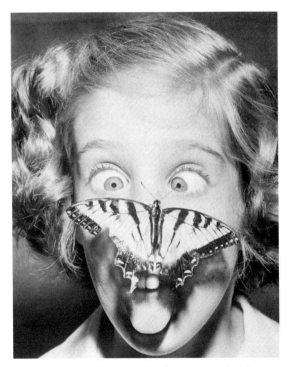

"Will I always look so goofy?"

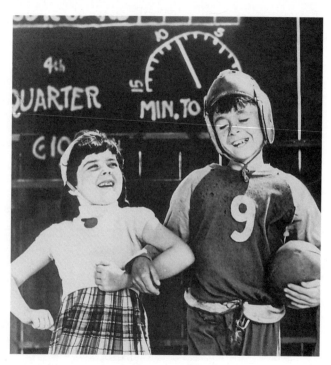

"Will I ever fit in?"

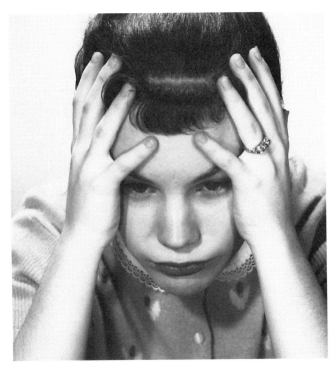

"And how come my folks don't have a clue?"

She's on a roller coaster of emotions
and you're along for the ride.

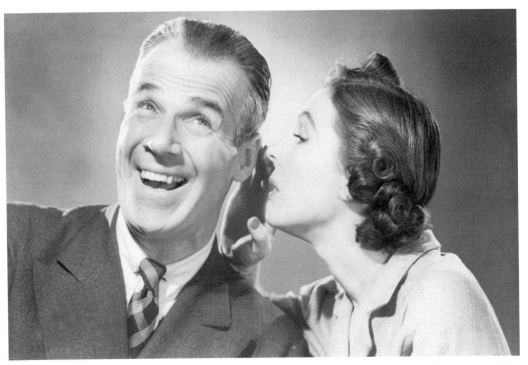

"We're parents, dear. No matter what we say, it's going to be wrong."

She also starts spending more time on the phone —even when she's eating, reading or watching TV.

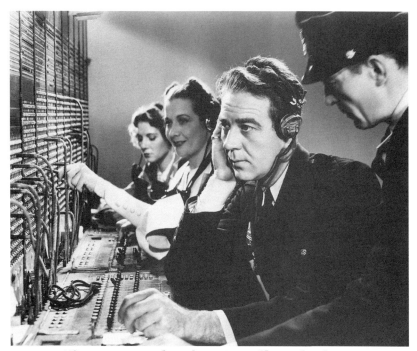

"Seems your daughter is still on the line.
Would you like the police to step in?"

Tip 5

Listen to her feelings.

Let her speak from the heart about her feelings and thoughts — without rushing in with your own solution.

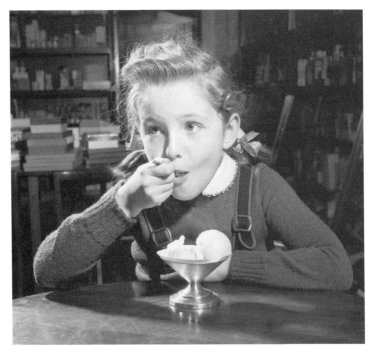

"So how can I be friends with Lisa
after what Debbie said?"

And let her know it's okay to be angry, sad, or to just say "No."

"Teach her to say No? I don't think that's
something we need to *teach* that girl."

Tip 6

Give her great role models.

Teach her about women who made their mark in the world. (And let your own life serve to guide her as well.)

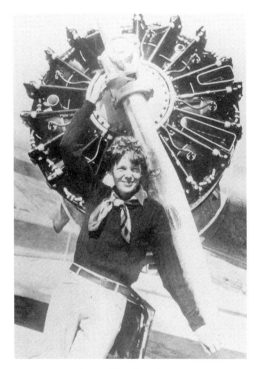

Amelia Earhart

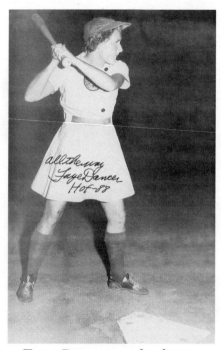

Faye Dancer and others,
who formed a league of their own.

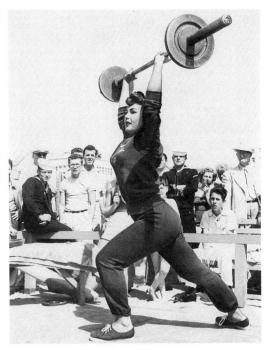

Shirley Tanny,
who combined beauty and strength.

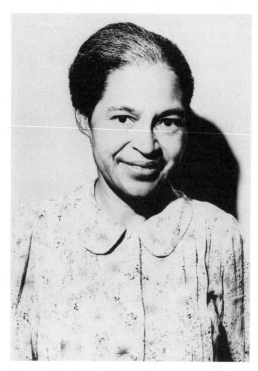

Rosa Parks, who calmly said No.

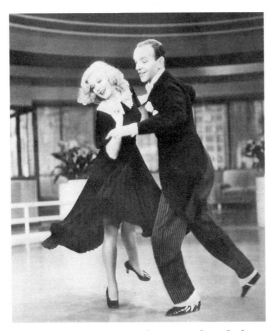

And Ginger Rodgers, who did
everything Fred Astaire did,
only backwards and in high-heels.

Who'll be the next to lead the way?
It could just be...

Your own little girl.

So teach her well…

Then let her go.

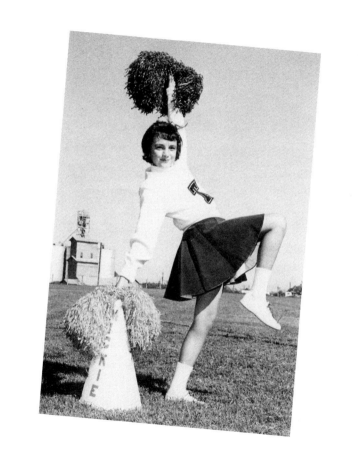

And that's how you raise…

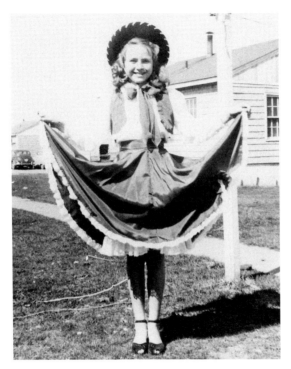

A very fine girl.

Also available in the "Picture Books for Grown Ups" series...

Fairy Tales Can Come True

(Just not every day!)

J.S. Salt

How to keep the love in your love life

A Picture Book
for Grown-Ups

More "Picture Books for Grown-Ups"

Boys Will Be Boys

Fairy Tales Can Come True

My Heart Belongs to Dad

My Heart Belongs to Mom

Also By J.S. Salt

How To Be The Almost Perfect Husband:
By Wives Who Know

How To Be The Almost Perfect Wife:
By Husbands Who Know

What The World Needs Now:
Kids' Advice on Treating People Right